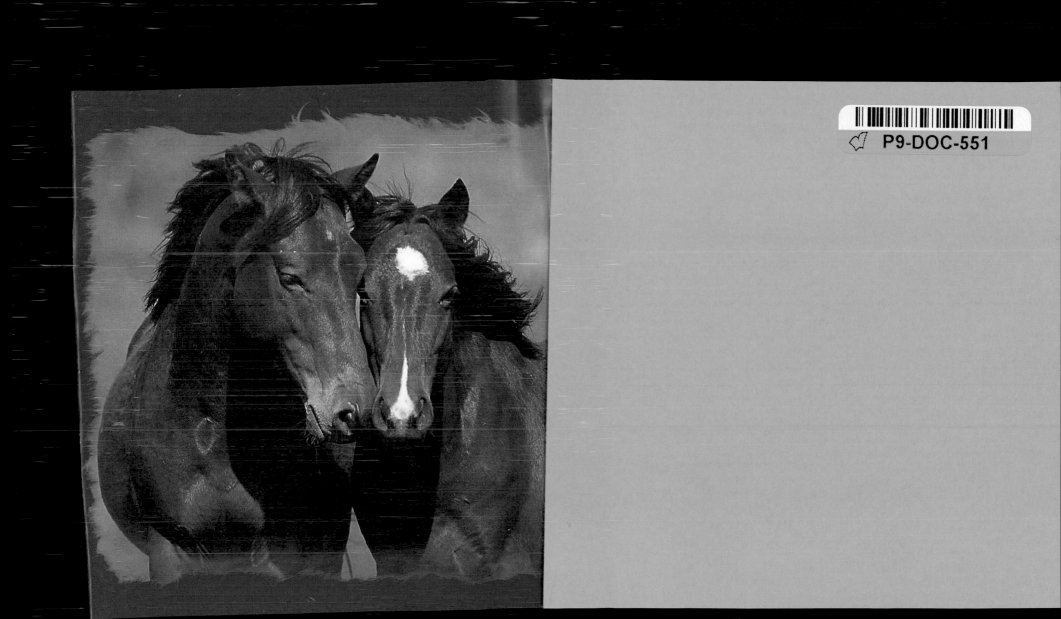

101
Uses
for a
Horse

101
Uses
for a
Horse

Willow Creek Press
Minocqua, Wisconsin

101 Uses for a Horse
Edited by Melissa Sovey-Nelson

© 2003 Willow Creek Press

Published by Willow Creek Press
P.O. Box 147 • Minocqua, Wisconsin 54548

Design: Andrea Donner

Printed in Canada

Willow Creek®
P R E S S

Horses as

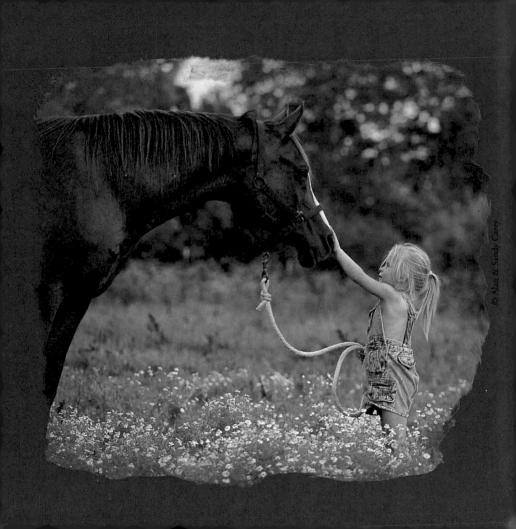

. . . as

faithful

companions

1 *Yoga partner*

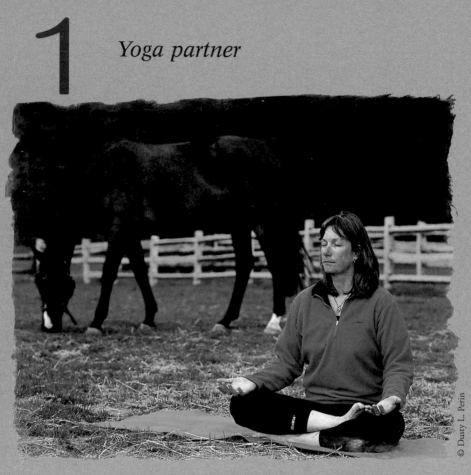

© Dusty L. Perin

2 *Cot*

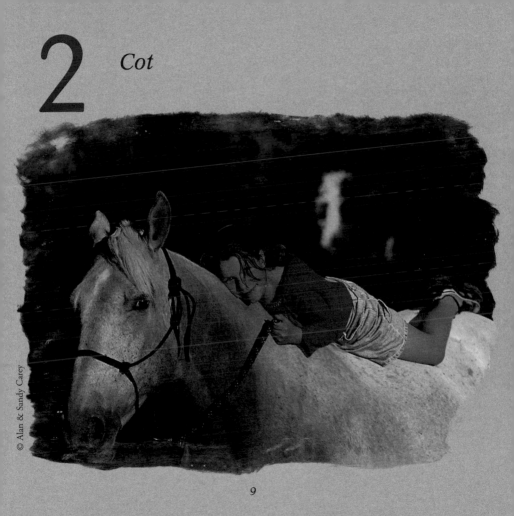

3

Someone to laugh at your jokes

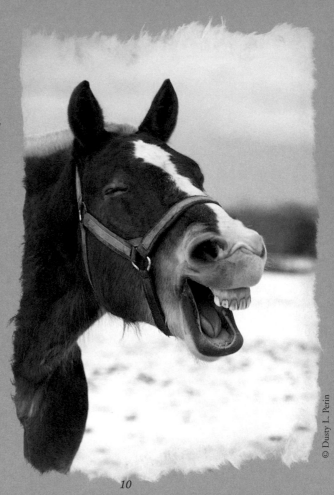

© Dusty L. Perin

4 *Matchmaker*

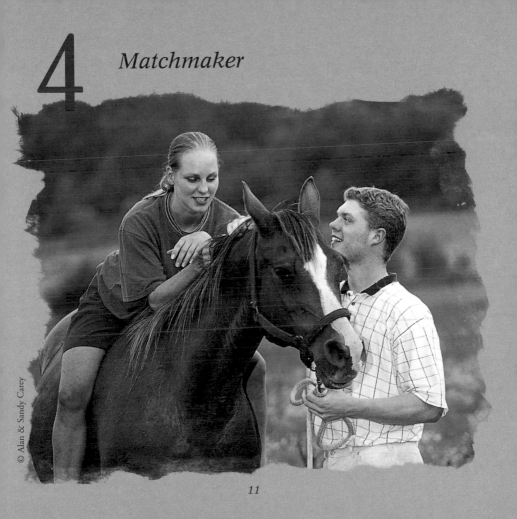

© Alan & Sandy Carey

5 *Someone to relax with...*

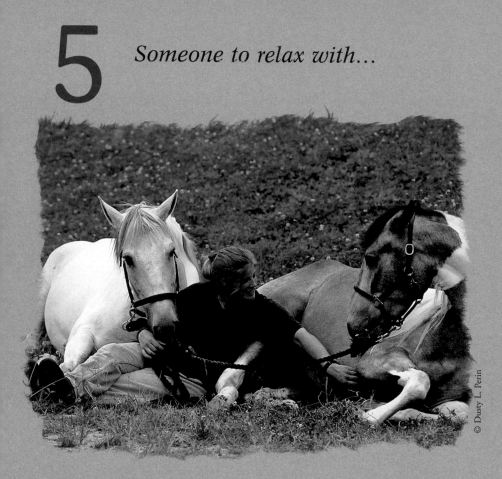

© Dusty L. Perin

6

...and to share a drink with

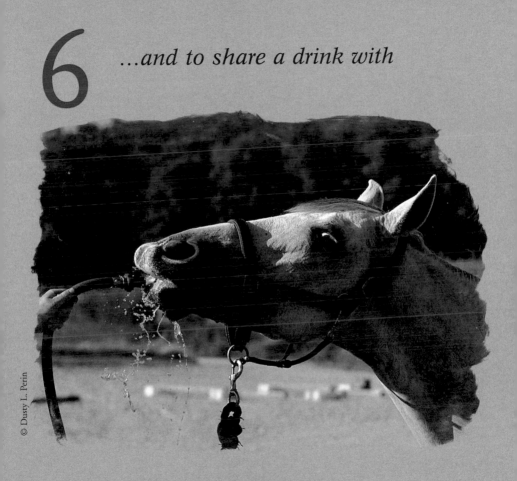

© Dusty L. Perin

7 *Teammate*

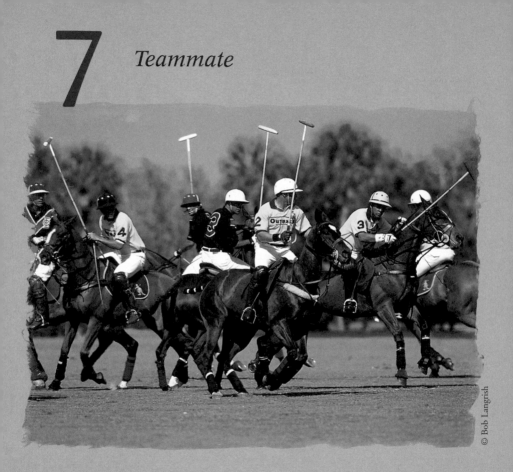

© Bob Langrish

8
Classmate

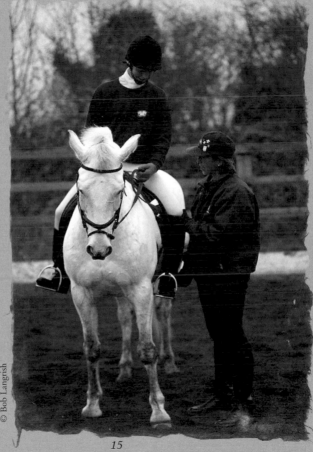

© Bob Langrish

9 *Campmate*

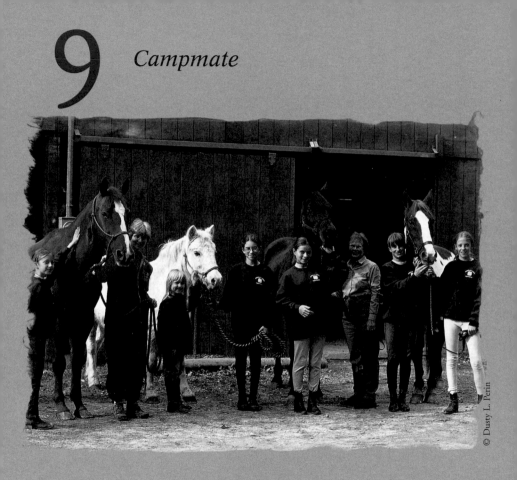

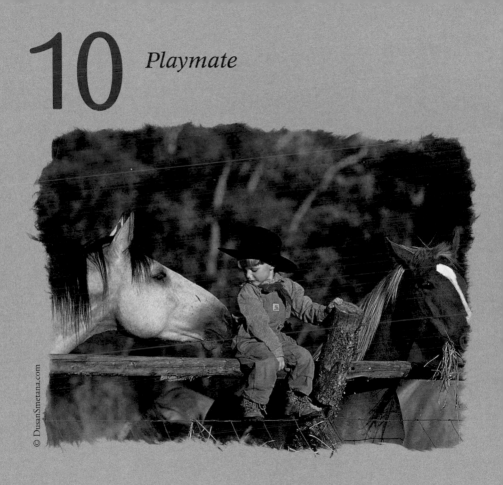

11
Babysitter

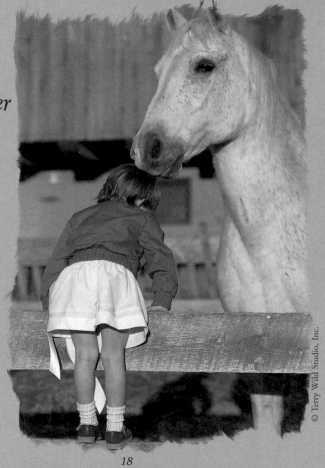

Mountain to climb

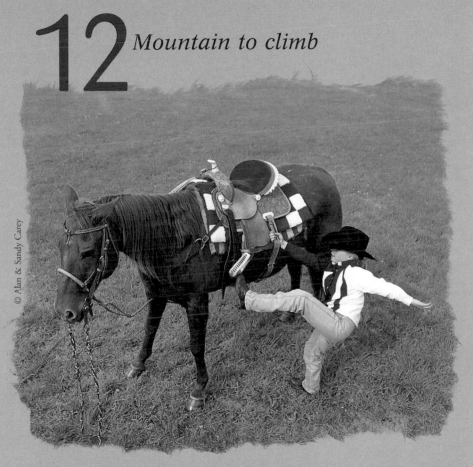

© Alan & Sandy Carey

13

 *Someone to tell your
troubles to...*

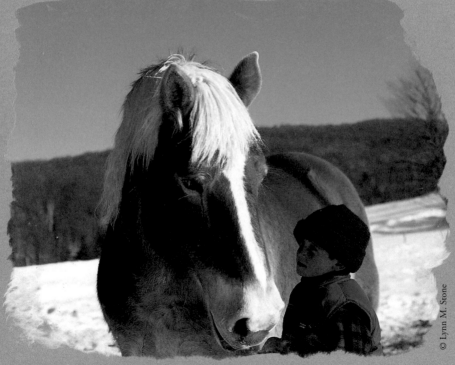

© Lynn M. Stone

14

*...who
will really
listen*

© Lynn M. Stone

15

Someone to soar with

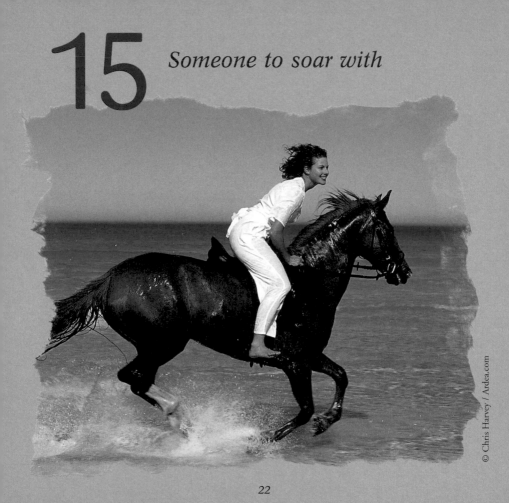

© Chris Harvey / Ardea.com

16 *Someone to bathe with*

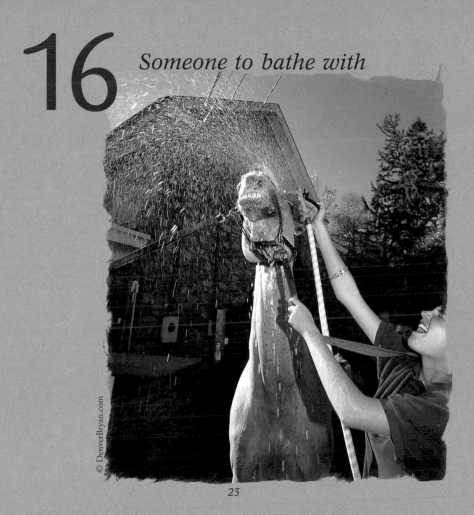

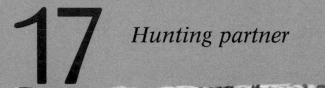

17 *Hunting partner*

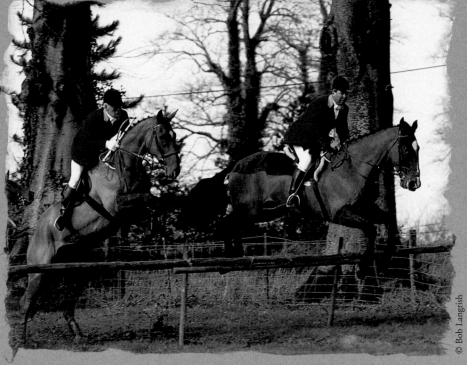

© Bob Langrish

18 *Workout partner*

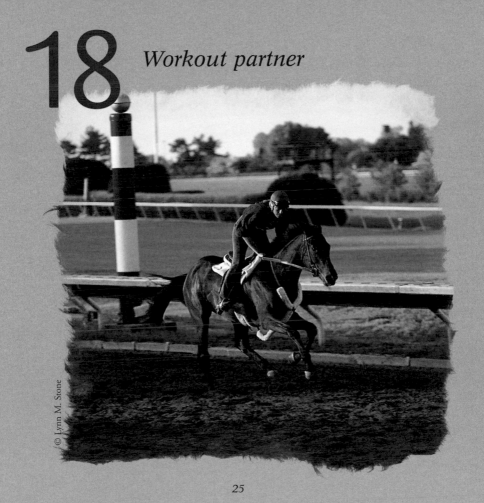

© Lynn M. Stone

19

Someone
to set...

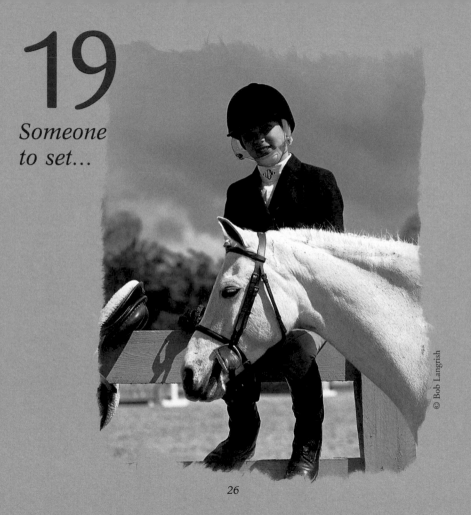

© Bob Langrish

20

...and achieve goals with

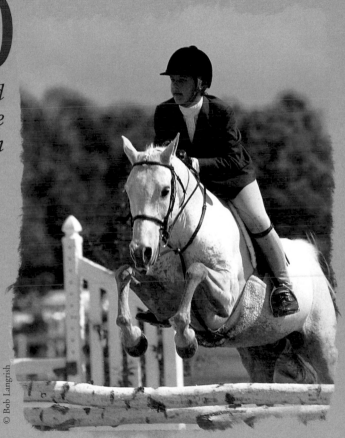

© Bob Langrish

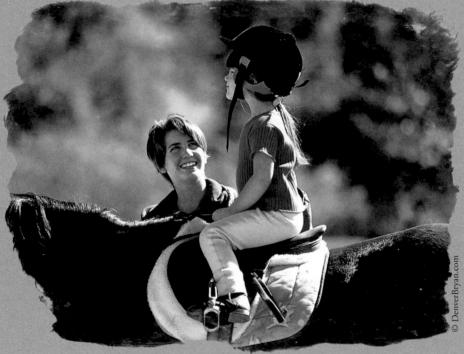

21 *Builder of self-esteem…*

© DenverBryan.com

22

...and courage

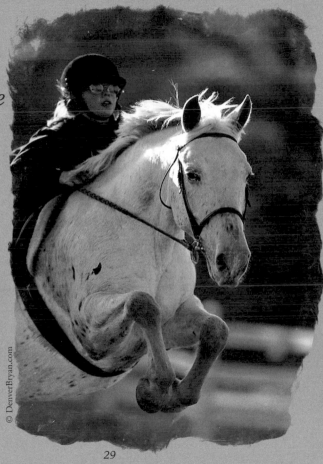

© DenverBryan.com

23

Someone to make you a stable person

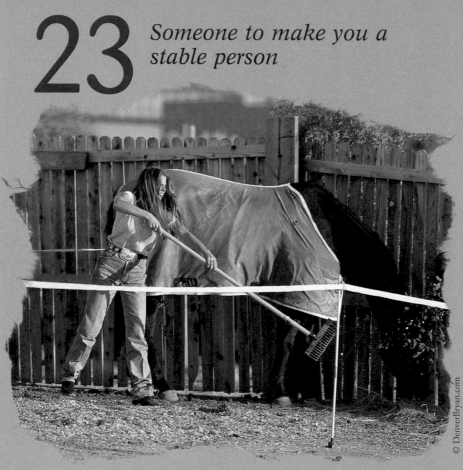

© DenverBryan.com

24
Best friend

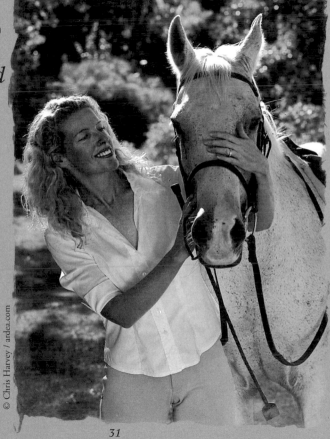

25

Someone to grow up with...

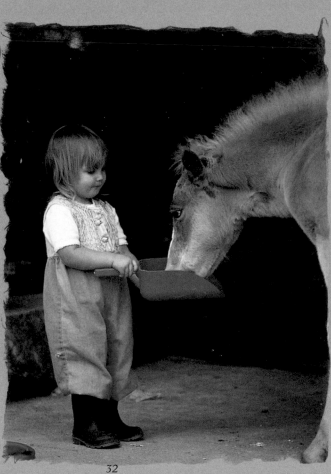

© Dusty L. Perin

26 *...and to grow old with*

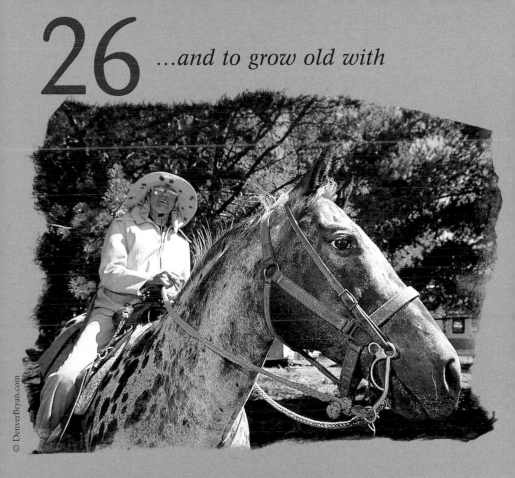

© DenverBryan.com

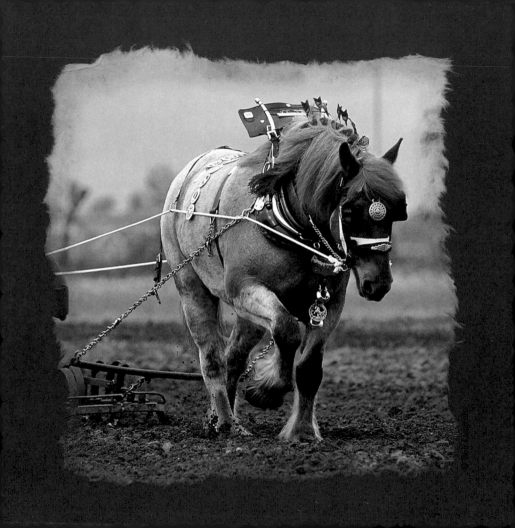

. . . as

tireless

workers

27 *Logger*

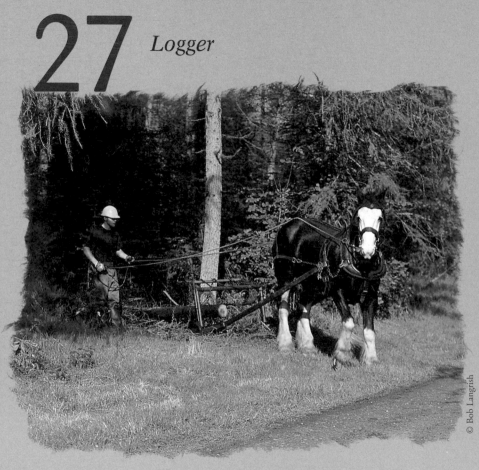

© Bob Langrish

28 *Lawn mowers*

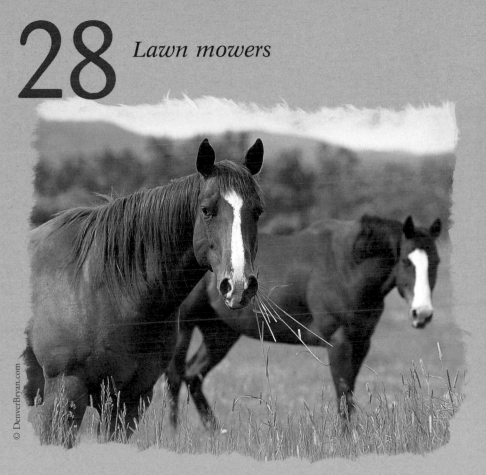

© DenverBryan.com

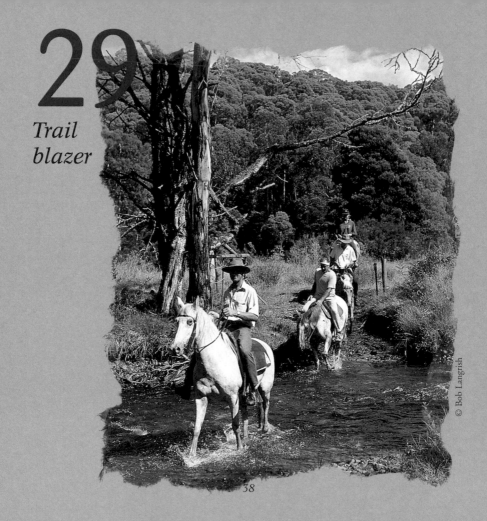

29
Trail blazer

© Bob Langrish

30 *Taxi*

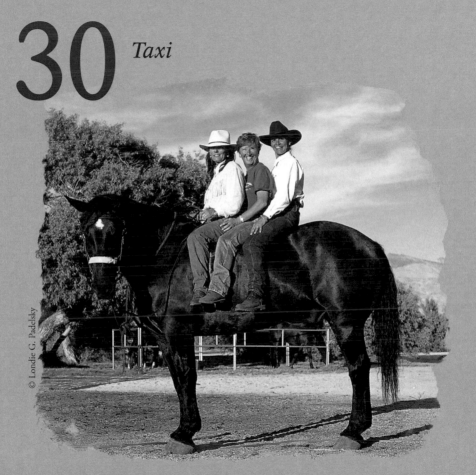

Bus driver

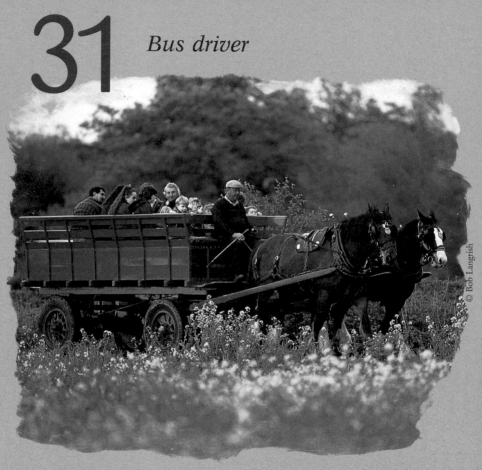

© Bob Langrish

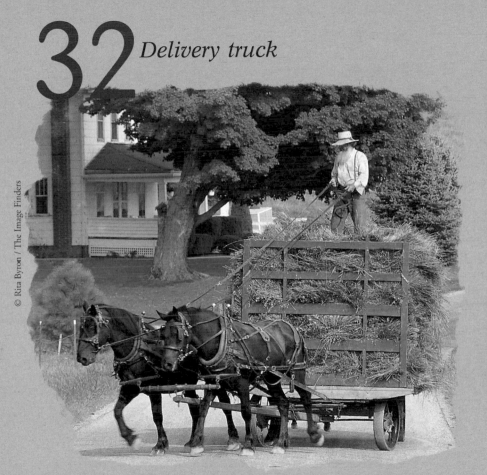

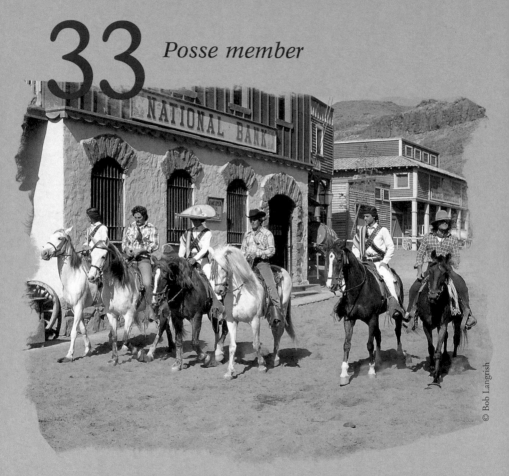

© Bob Langrish

34

Police officer

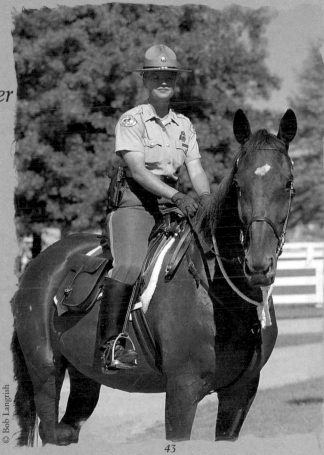

© Bob Langrish

35 *Farmhand*

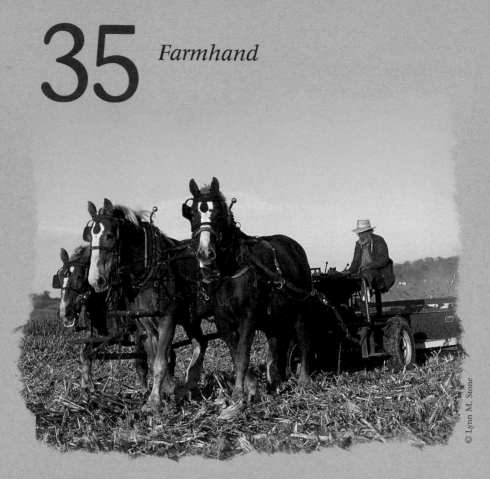

© Lynn M. Stone

36 *Chauffeur*

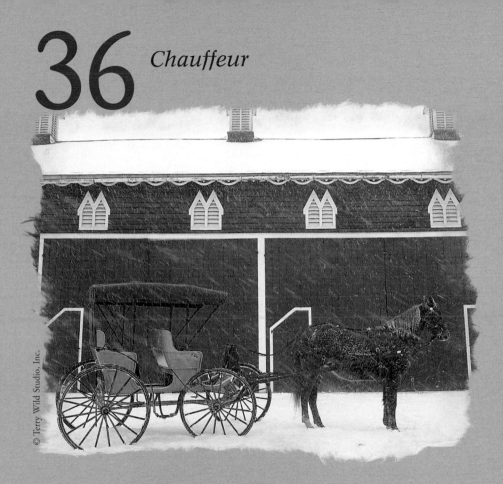

37 *Competitor*

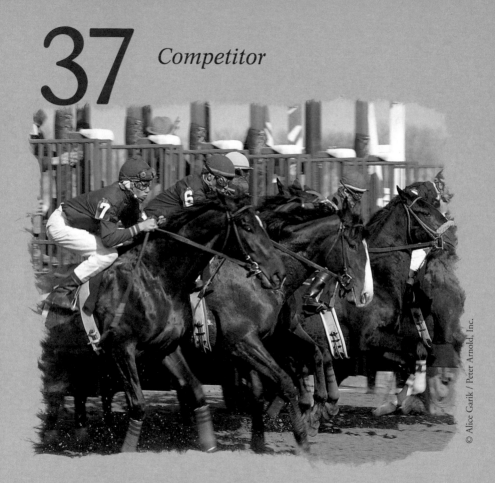

© Alice Garik / Peter Arnold, Inc.

38 *Crowd control*

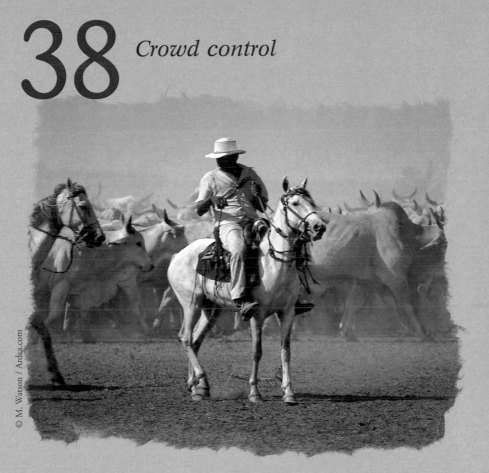

© M. Watson / Ardea.com

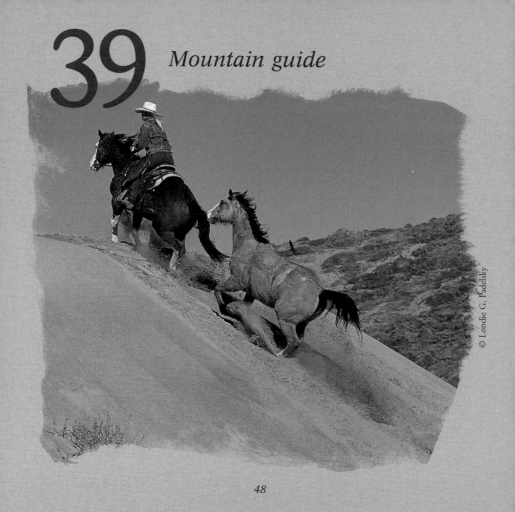

39 *Mountain guide*

40 *Tour guide*

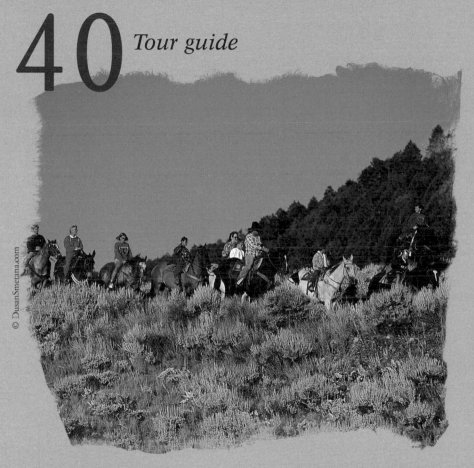

41

Gardener

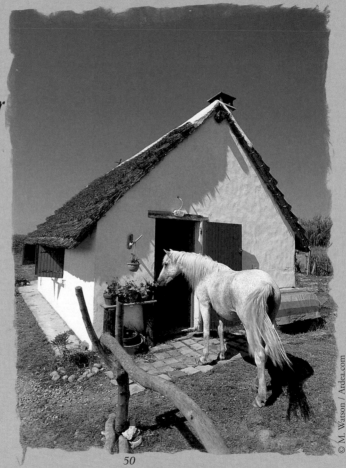

© M. Watson / Ardea.com

42
Valet

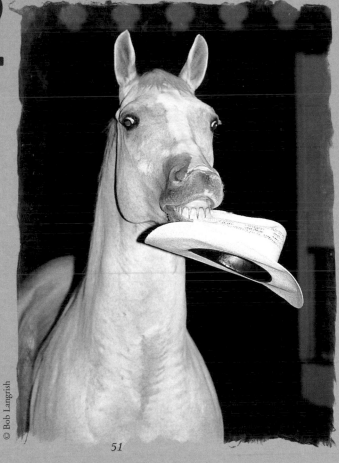

© Bob Langrish

43 *Mail carrier*

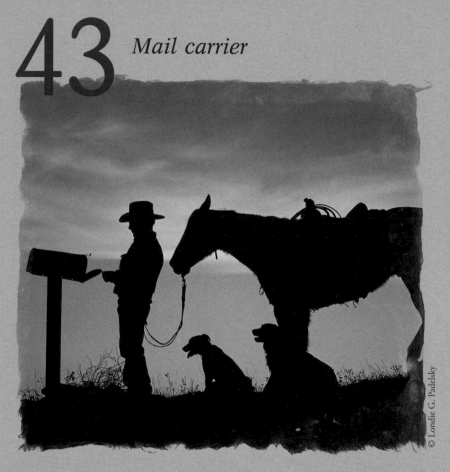

© Londie G. Padelsky

44 *Athlete*

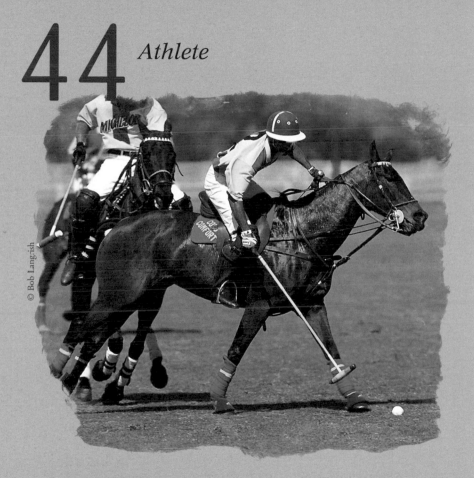

© Bob Langrish

45 *Someone to help make maple sugar*

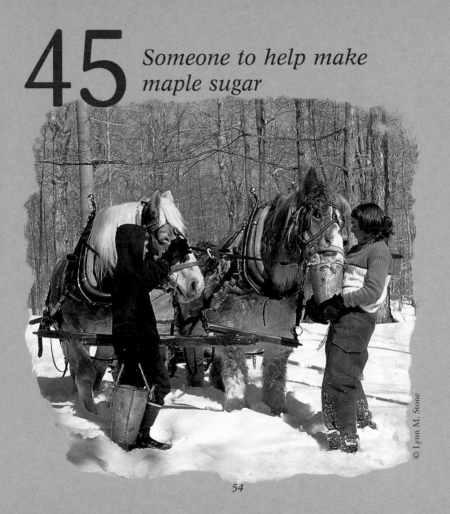

© Lynn M. Stone

46

Circus performer

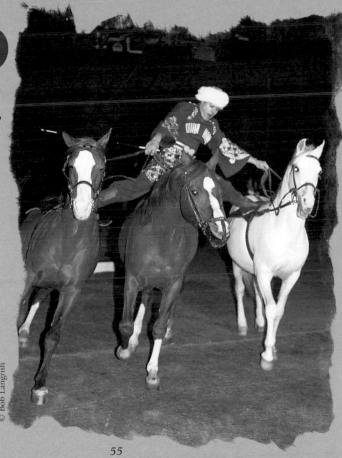

© Bob Langrish

47

Turn signal

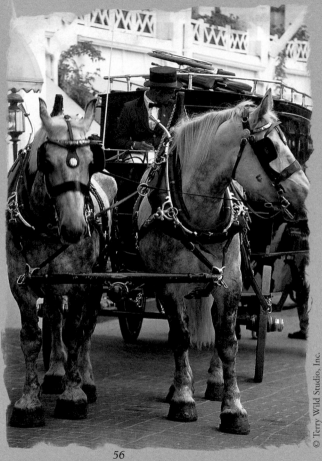

48 *Team player*

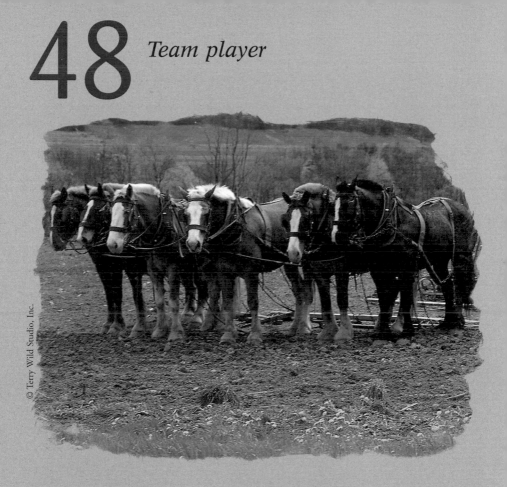

© Terry Wild Studio, Inc.

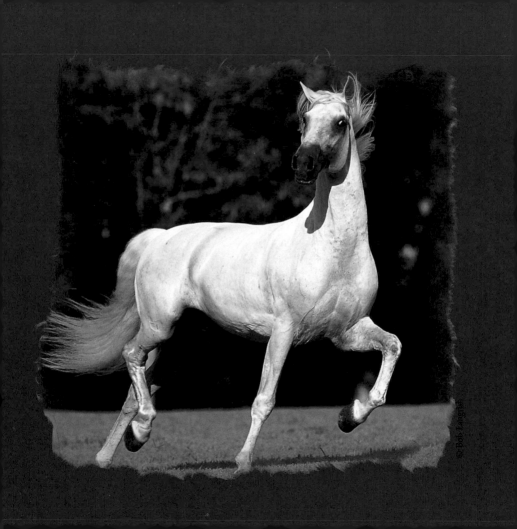

© Bob Langrish

. . . and
specialty
uses

49

Head rest

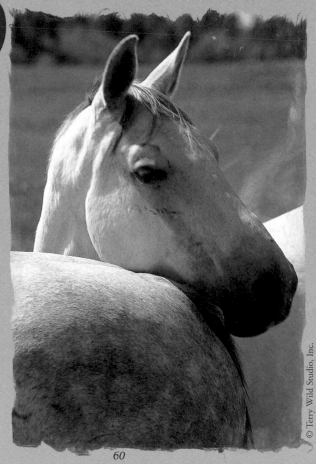

50

*Window
dressing*

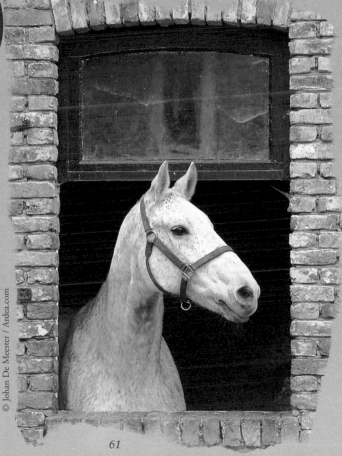

© Johan De Meester / Ardea.com

51 *Family sedan*

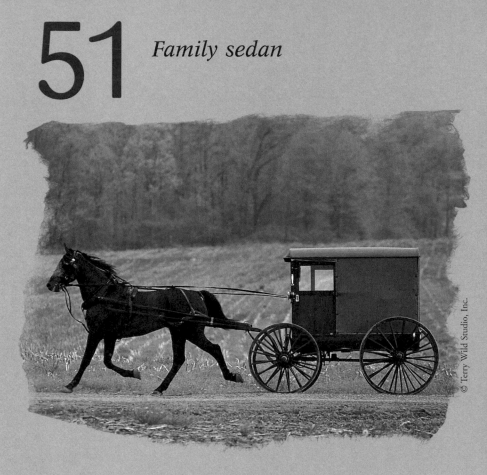

© Terry Wild Studio, Inc.

52

Lawn ornaments

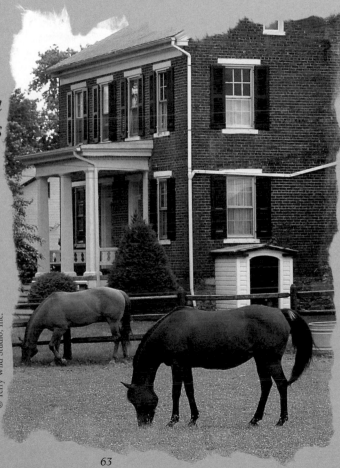

© Terry Wild Studio, Inc.

53 *Beach comber*

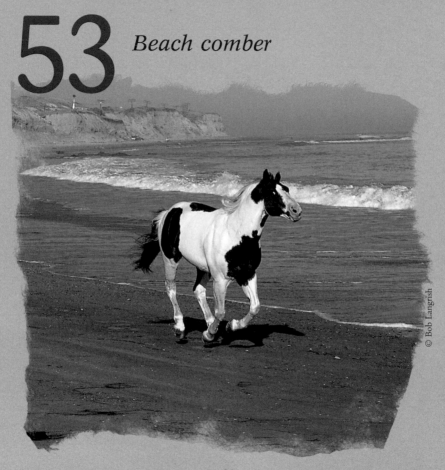

© Bob Langrish

54 *Gatekeeper*

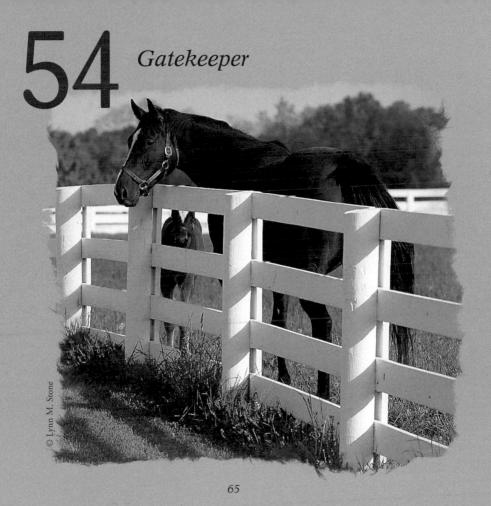

© Lynn M. Stone

55 *Alarm bell*

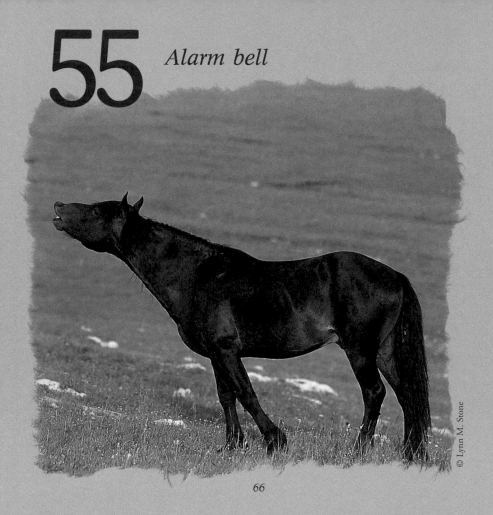

© Lynn M. Stone

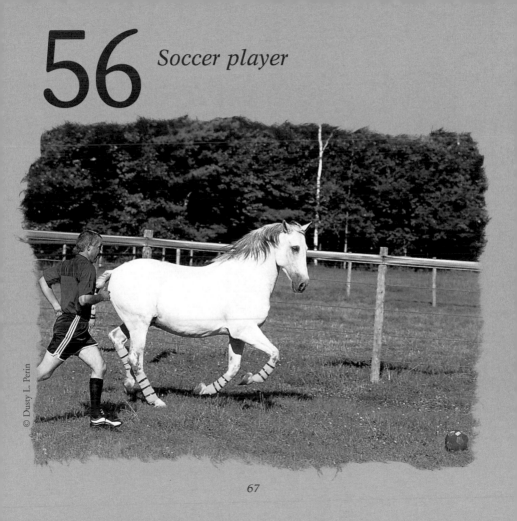

56 Soccer player

© Dusty L. Perin

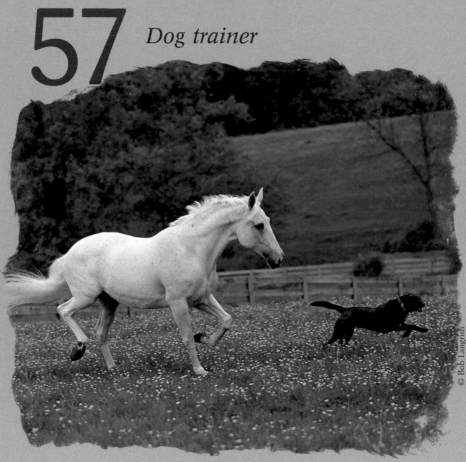

57 *Dog trainer*

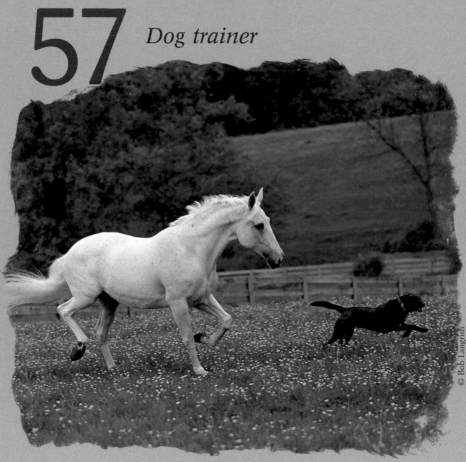

58 *Dog walker*

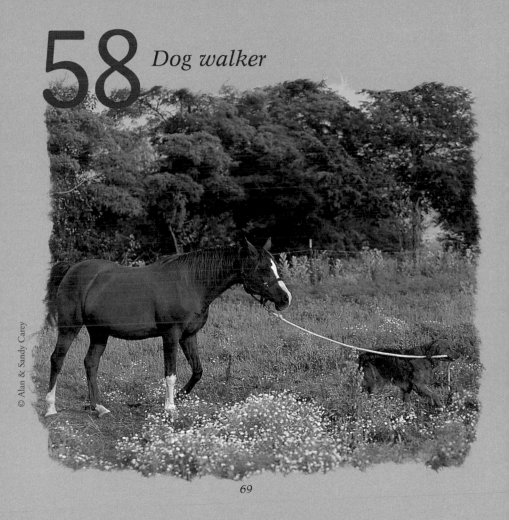

© Alan & Sandy Carey

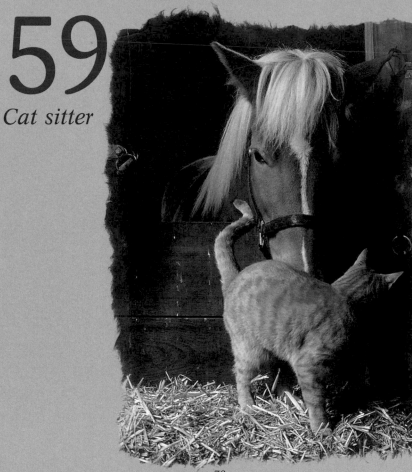

59

Cat sitter

© Renee Stockdale / AnimalsAnimals

60

Calm in a storm

© Terry Wild Studio, Inc.

Someone to help you find your center

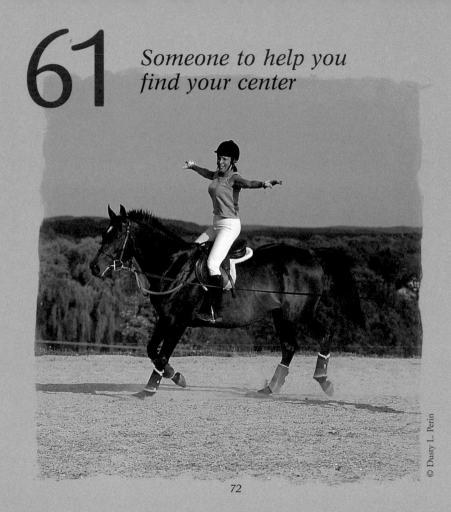

62

*Wordless
communicator*

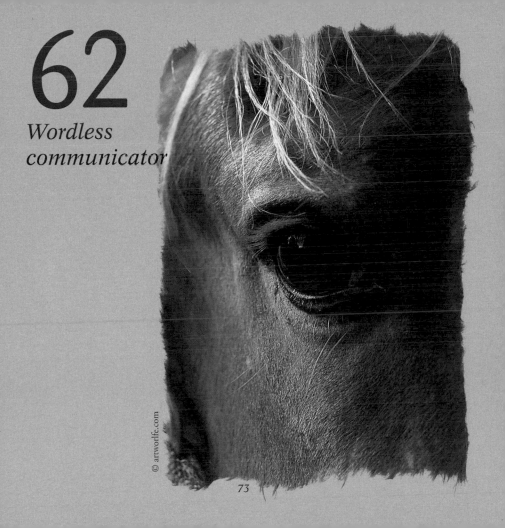

63

Ego booster

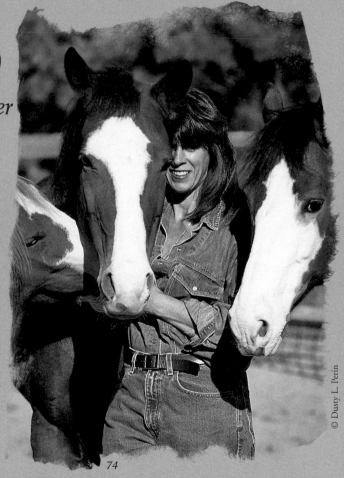

© Dusty L. Perin

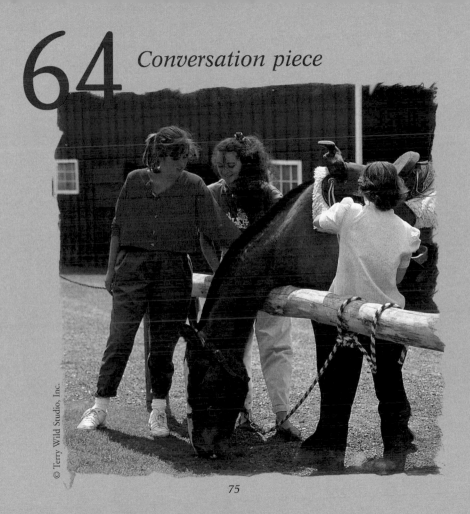

Someone to answer the door

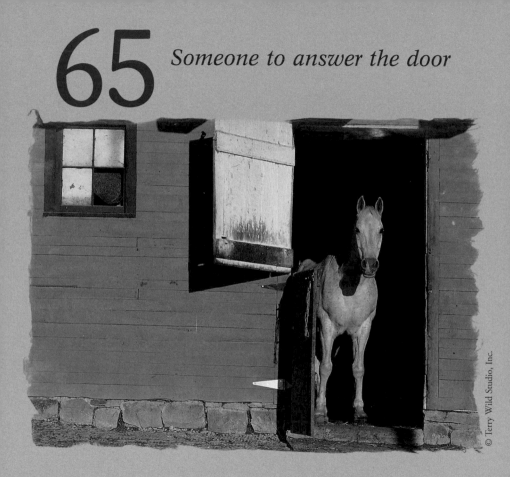

66
Lookout

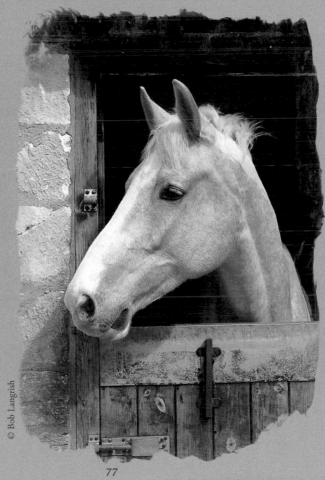

© Bob Langrish

67

Someone to bring out your maternal instincts

© Dusty L. Perin

68

Someone to share your pride with

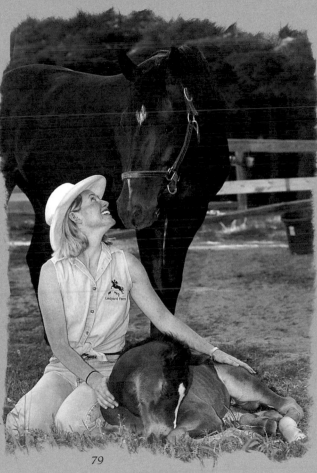

© Dusty L. Perin

79

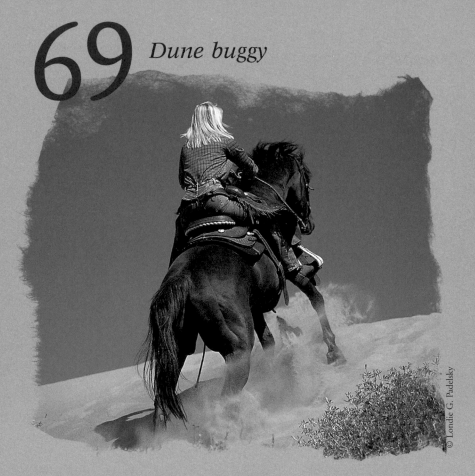

© Londie G. Padelsky

70 *Snowmobile*

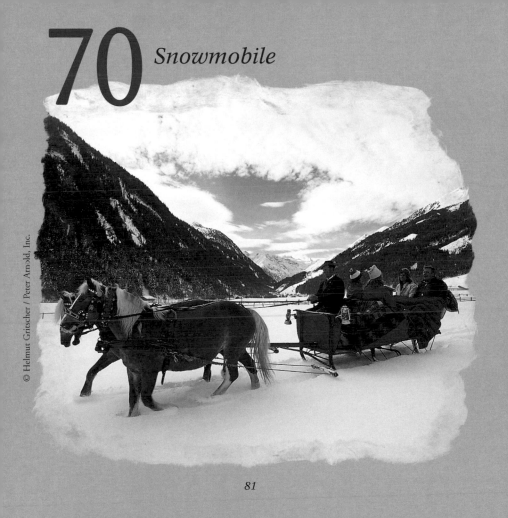

© Helmut Gritscher / Peter Arnold, Inc.

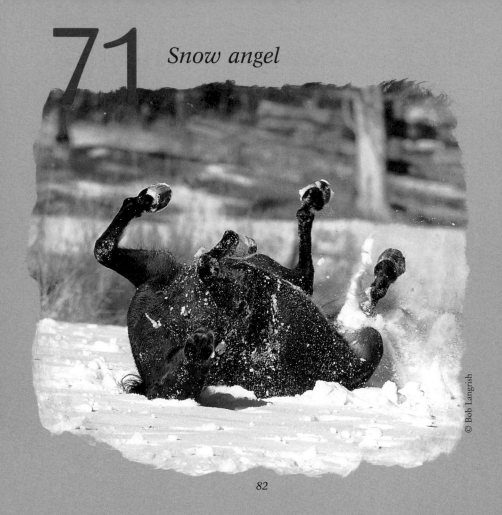

71 *Snow angel*

© Bob Langrish

72
Snowshoes

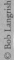

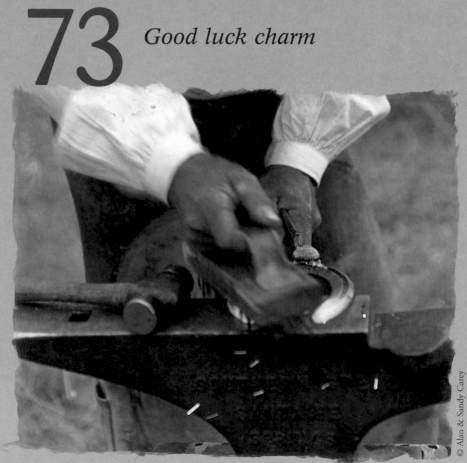

© Alan & Sandy Carey

Ceremonial leader

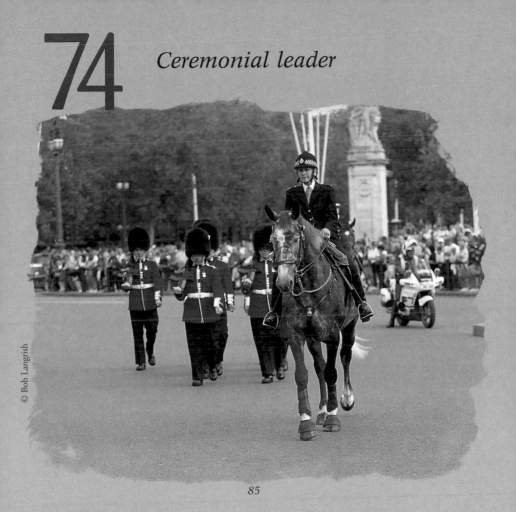

© Bob Langrish

*Partner in
defeat…*

© Bob Langrish

76

...and in triumph

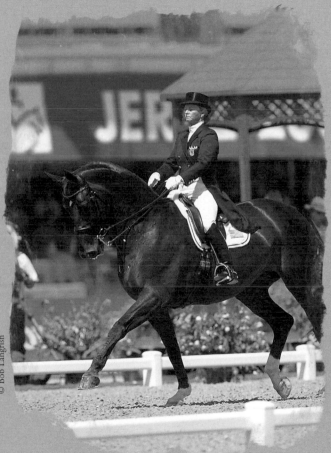

© Bob Langrish

77
Dandelion control

Photographer's assistant

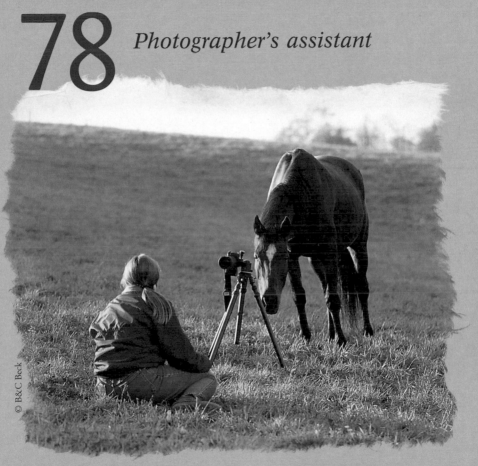

© B&C Beck

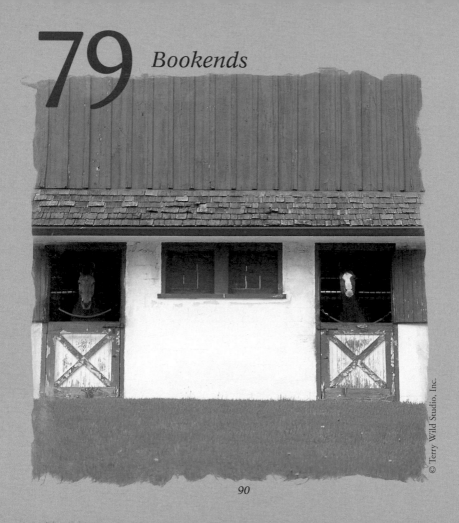

79 *Bookends*

80 *Someone to stand up for you*

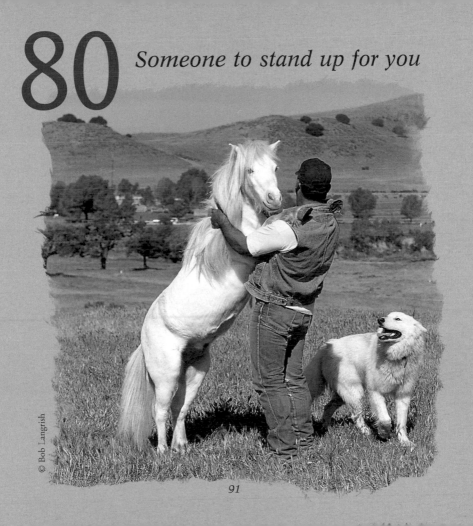

© Bob Langrish

81

*Role
model*

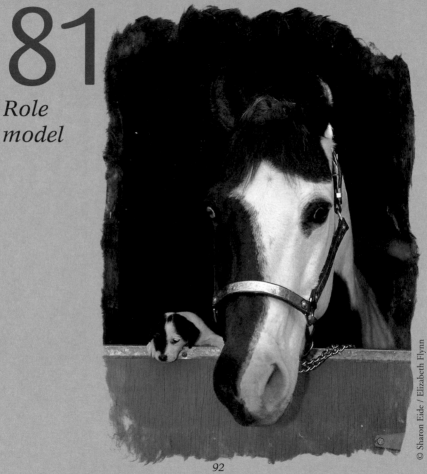

82
Supermodel

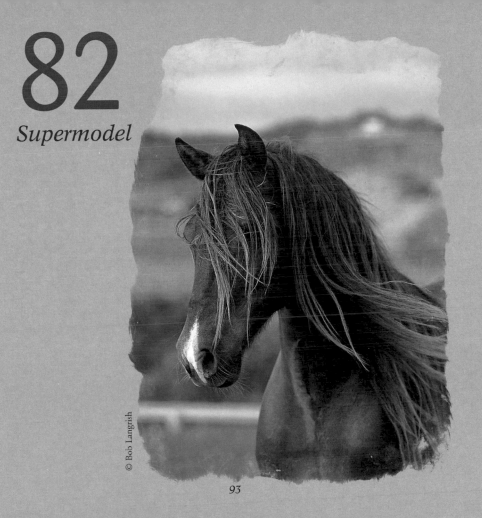

© Bob Langrish

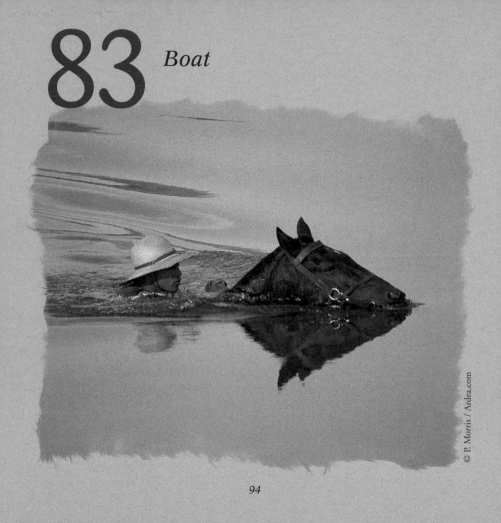

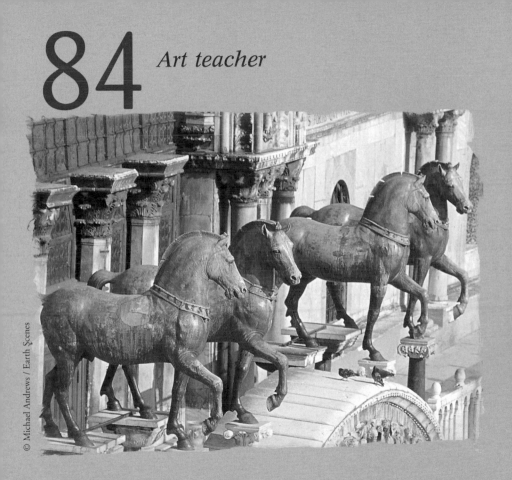

85 *Entertainer*

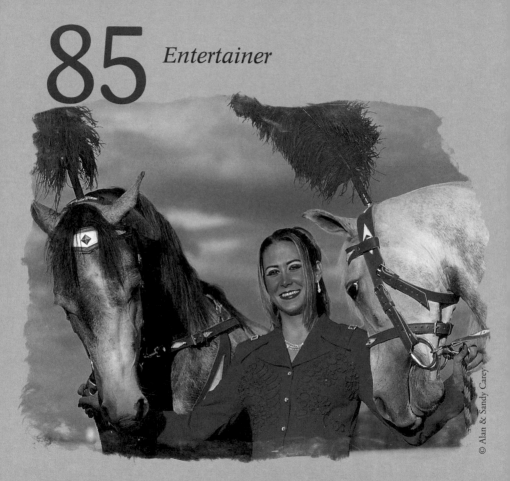

© Alan & Sandy Carey

86 *Telephone booth*

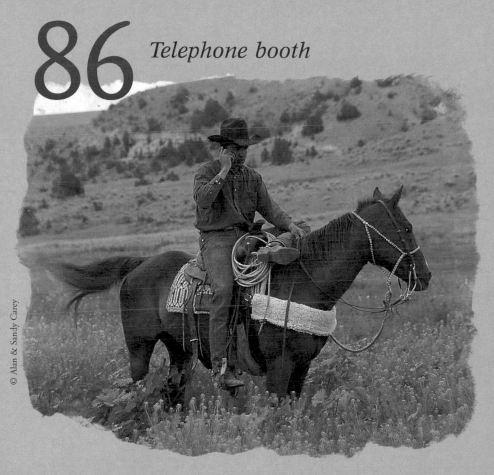

© Alan & Sandy Carey

87

*Honest
commentator*

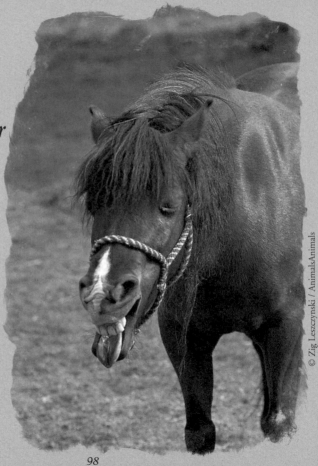

© Zig Leszczynski / AnimalsAnimals

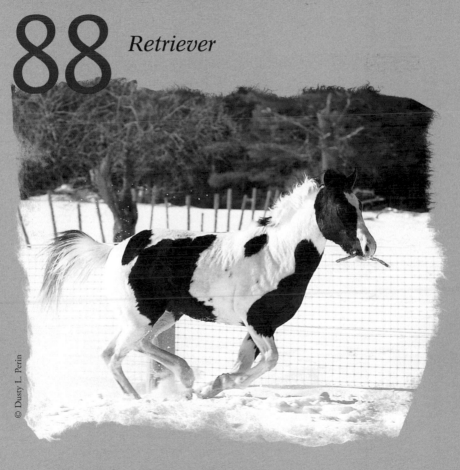

© Dusty L. Perin

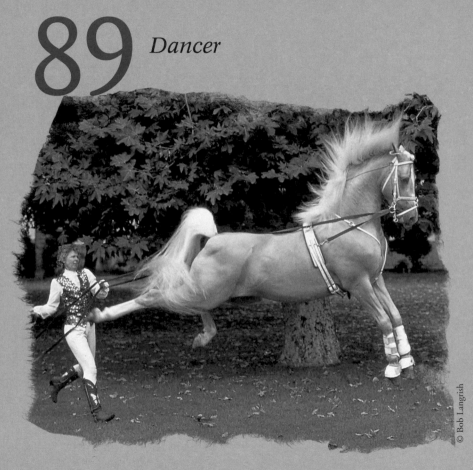

© Bob Langrish

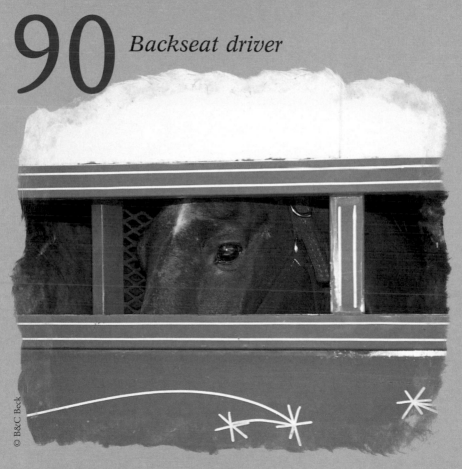

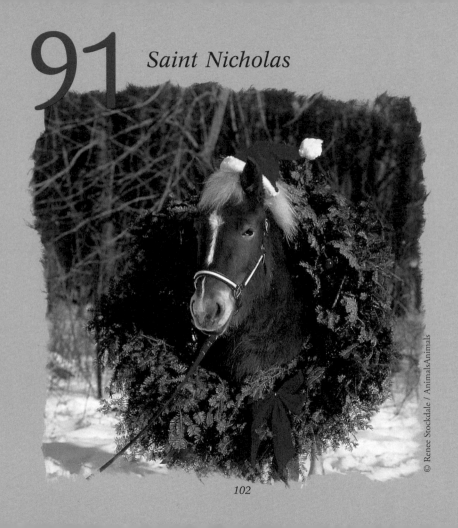

© Renee Stockdale / AnimalsAnimals

92

*Floral
arranger*

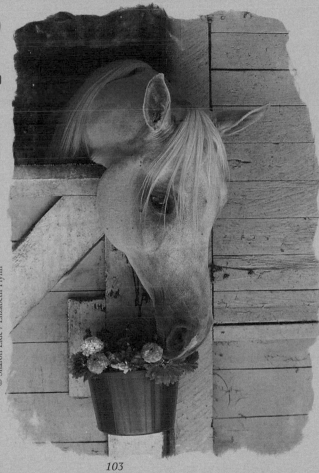

93
Motivator

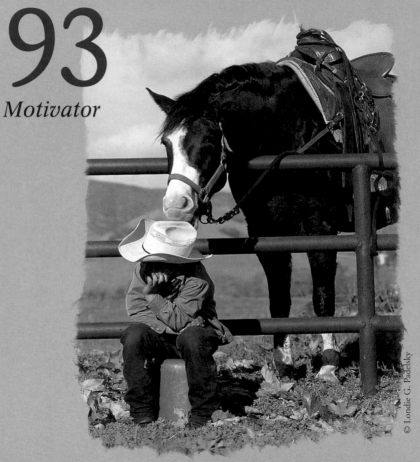

© Londie G. Padelsky

94

*Someone
to make
you reflect*

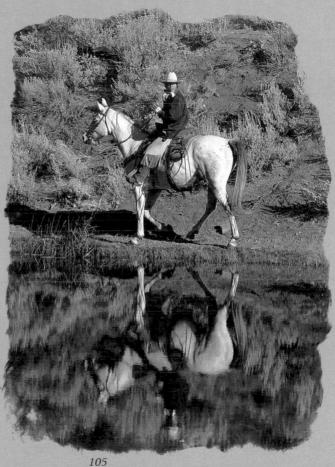

© Wendy Shattil / Bob Rozinski

95

*Someone to enrich
your horizons*

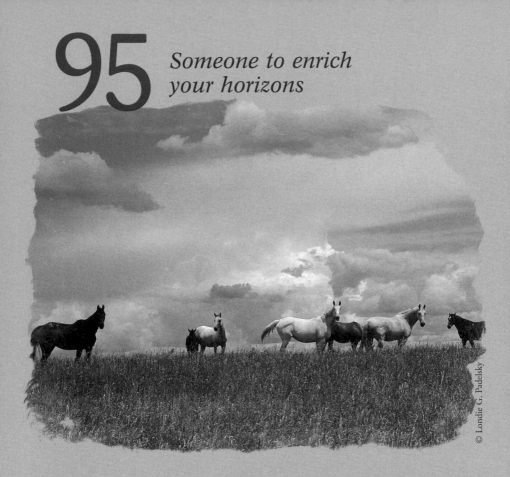

© Londie G. Padelsky

96

Someone
to bring
you roses

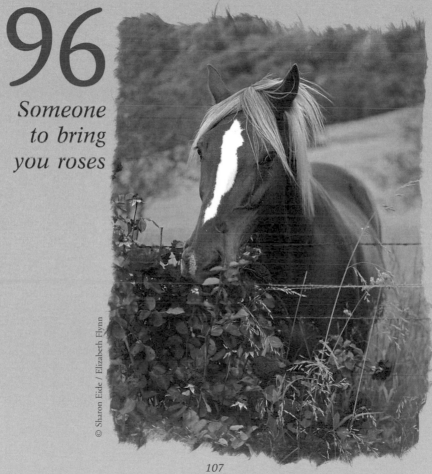

© Sharon Eide / Elizabeth Flynn

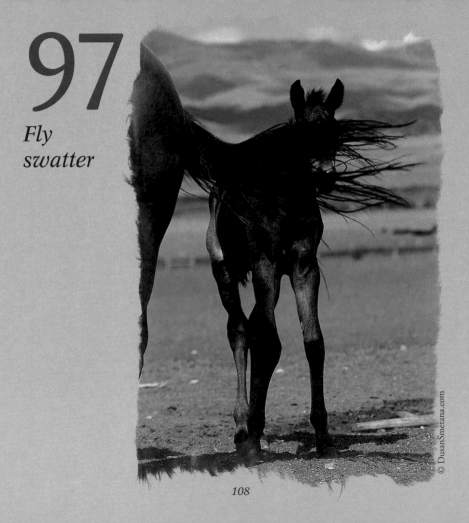

97

Fly swatter

© DusanSmetana.com

Childhood memory

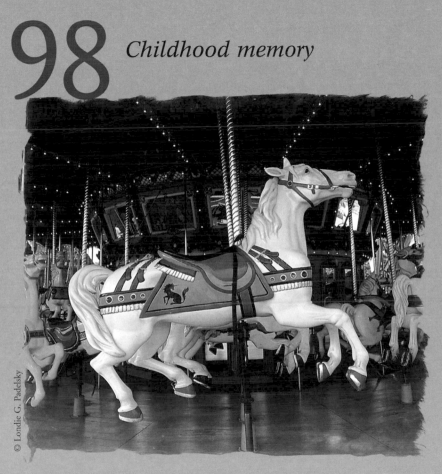

© Londie G. Padelsky

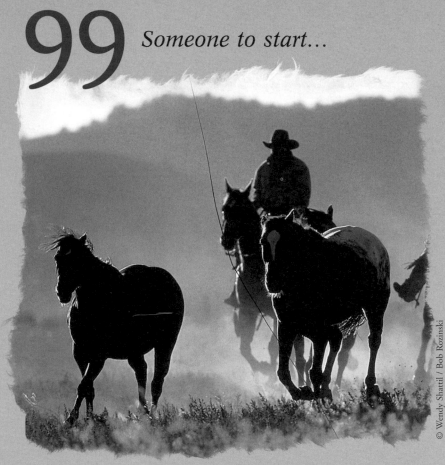

99

Someone to start...

© Wendy Shattil / Bob Rozinski

100 *... and end your day with*

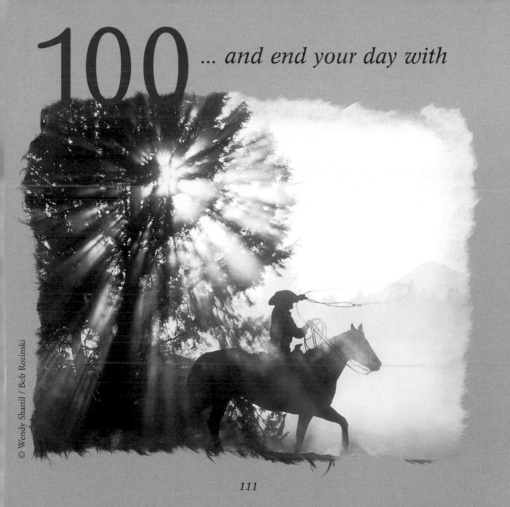

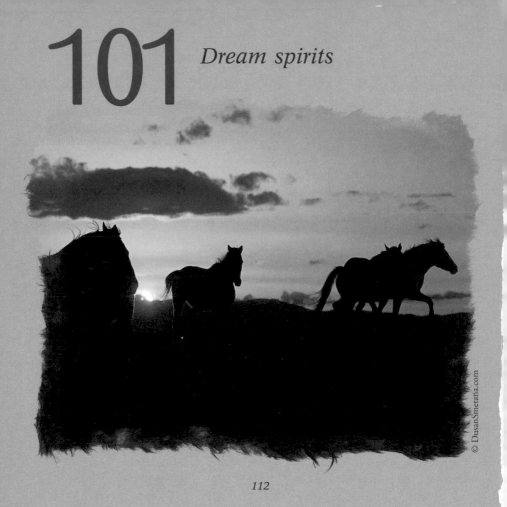